Kristy Rice

*Watercolor Discovery and
Releasing Your Creative Spirit*

the
ARt
for
Joy's Sake

Journal

SCHIFFER PUBLISHING

4880 Lower Valley Road • Atglen, PA 19310

To my son Isaac, Izzy man.
I didn't know a flower's full beauty until
you first picked one for me.

Copyright © 2019 by *Kristy Rice*

Designed by Danielle D. Farmer
Cover design by Danielle D. Farmer
Type set in Tiffany LT BT

ISBN: 978-0-7643-5767-1
Printed in China

Published by Schiffer Publishing, Ltd.
4880 Lower Valley Road
Atglen, PA 19310
Phone: (610) 593-1777; Fax: (610) 593-2002
E-mail: Info@schifferbooks.com
Web: www.schifferbooks.com

For our complete selection of fine books on this and related subjects, please visit our website at www.schifferbooks.com. You may also write for a free catalog.

Schiffer Publishing's titles are available at special discounts for bulk purchases for sales promotions or premiums. Special editions, including personalized covers, corporate imprints, and excerpts, can be created in large quantities for special needs. For more information, contact the publisher.

We are always looking for people to write books on new and related subjects. If you have an idea for a book, please contact us at proposals@schifferbooks.com.

Other Schiffer Books by the Author:

The Painter's Wedding: Inspired Celebrations with an Artistic Edge, ISBN 978-0-7643-5442-7

Kristy's Spring Cutting Garden: A Watercoloring Book, ISBN 978-0-7643-5335-2

Watercolor Cards: Illustrations by Kristy Rice, ISBN 978-0-7643-5766-4

Other Schiffer Books on Related Subjects:

Pigments of Your Imagination: Creating with Alcohol Inks, 2nd ed., Cathy Taylor, ISBN 978-0-7643-5133-4
Organic Embroidery, Meredith Woolnough, ISBN 978-0-7643-5613-1

LETTER *from* *the* ARTIST

I want peace for you, the kind of peace I know comes from a brush in hand, where fears cannot reach. Do I expect you to become a professional artist or paint every day? No, not at all. Expectations don't hold much value in this space. Do I wish for you to carve out contentment and reclaim the small reverie moments lost to chaos and the too-much that is your life? Yes.

The Art for Joy's Sake Journal is my wish for you, and it just so happens that the language of watercolor is the one I speak best, so it is my offering to you. Art for your joy's sake may become something else. It begins here with brush and paint but will perhaps evolve into cooking, knitting, or writing, and praise be for all of it. I'm looking to inspire not only lifelong painters but also lifelong makers and hoarders . . . hoarders of time and moments that make us feel good. Let me urge you to be fiercely protective of your time and how you spend its virtues. Watercolor in all its dynamic melodies has an uncanny ability to teach us about time. Watercolor trains us in patience and begs us to revel in small successes.

As you journey into the pages here,
you'll discover:

PAINTING PAGES

Nine patterns await. One of each is painted by moi, and two are for your own experimenting! Each painting page is printed in soft gray on double-sided watercolor paper. As you paint, the more detail you add, the more the outlines will disappear. This is hot press (smooth) watercolor paper and will feel a bit different from heavily-textured versions. And yes, you can paint on *both* sides without fear of bleed-through with any water-based media.

Journaling Pages

These pages are designed to inspire some impromptu art making. Use what you have—pencils, crayons, your kid's watercolors . . . stickers, paper scraps, a glue stick, whatever. And don't worry, the paper can handle whatever you throw at it . . . literally.

Painting Exercises

I've included a few low-stress, enjoyable exercises that will surely get you more comfortable with a brush and some paint!

Lists (and Food!)

As artists, whether new or experienced, we have a tendency to get into creative slumps. Yes, me too. Even as someone who thrives on and feels best when painting, I don't always want to paint! So I'm sharing some of my favorite ways to get into the creative mood—perspective-renewing thoughts, books, and fun activities. Even a favorite recipe or two. What could be better?

Inspirational Artwork

Years ago I created an inspiration wall that can be seen as I raise my eyes above my computer monitors. It is filled with my favorite prints, quotes, art pieces, vintage what-not . . . essentially all the visual ephemera that makes me happy lives on this wall. For this book I've chosen a few of my favorite quotes and paired them with prints of my artwork, ready to hang on your own inspiration wall!

Throughout you will find "Joyful Tips," little snippets of wisdom meant to give you the most joyful experience. My hope is that each tip, from the best brushes to use for a particular exercise to general encouragement, will give you the chance for a more inspirational experience every time you open these pages!

Happy painting!

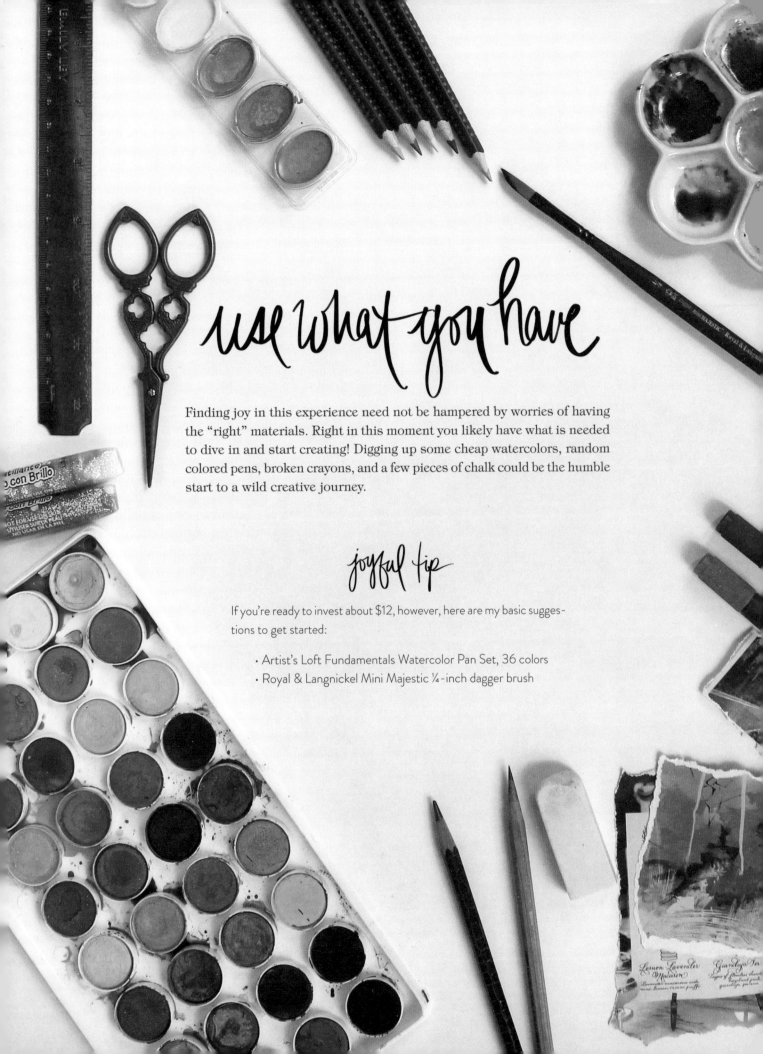

use what you have

Finding joy in this experience need not be hampered by worries of having the "right" materials. Right in this moment you likely have what is needed to dive in and start creating! Digging up some cheap watercolors, random colored pens, broken crayons, and a few pieces of chalk could be the humble start to a wild creative journey.

joyful tip

If you're ready to invest about $12, however, here are my basic suggestions to get started:

- Artist's Loft Fundamentals Watercolor Pan Set, 36 colors
- Royal & Langnickel Mini Majestic ¼-inch dagger brush

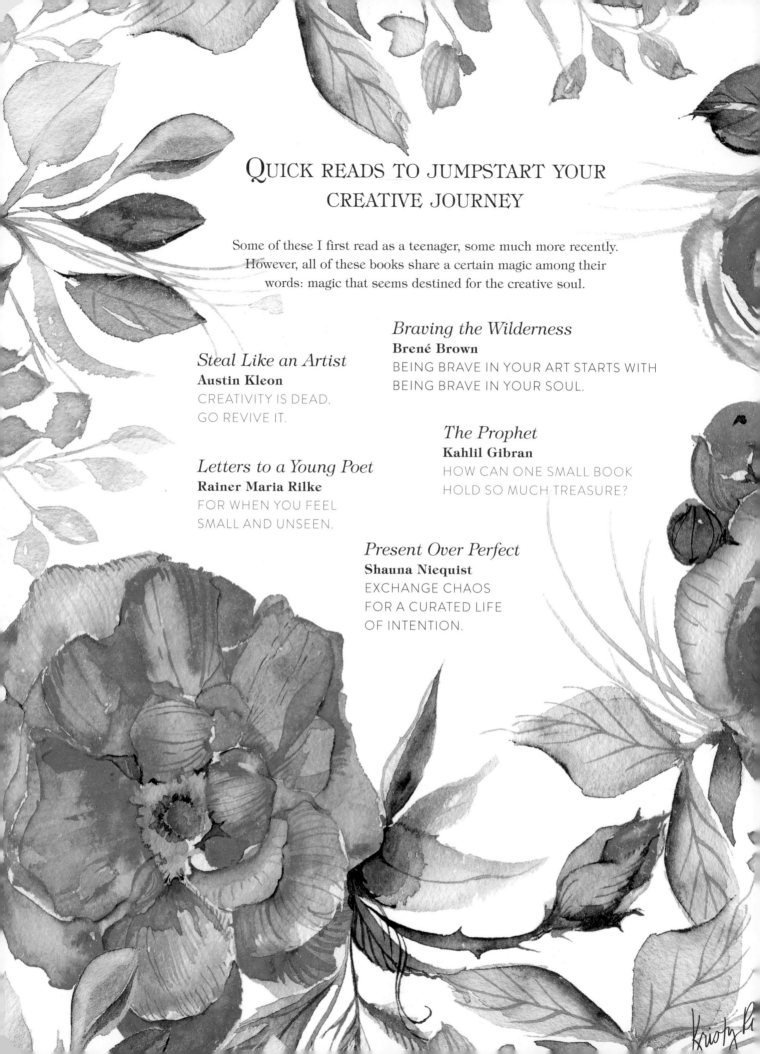

QUICK READS TO JUMPSTART YOUR CREATIVE JOURNEY

Some of these I first read as a teenager, some much more recently.
However, all of these books share a certain magic among their
words: magic that seems destined for the creative soul.

Steal Like an Artist
Austin Kleon
CREATIVITY IS DEAD.
GO REVIVE IT.

Letters to a Young Poet
Rainer Maria Rilke
FOR WHEN YOU FEEL
SMALL AND UNSEEN.

Braving the Wilderness
Brené Brown
BEING BRAVE IN YOUR ART STARTS WITH
BEING BRAVE IN YOUR SOUL.

The Prophet
Kahlil Gibran
HOW CAN ONE SMALL BOOK
HOLD SO MUCH TREASURE?

Present Over Perfect
Shauna Niequist
EXCHANGE CHAOS
FOR A CURATED LIFE
OF INTENTION.

Write down the top 10 things that scare you when making art. Make a numbered list and be organized about getting your thoughts down. Or use torn-up magazines to create a fear-bashing collage! The point is to invest in the enlightening power this page can have for you. Better to get it out than hold those fears in! Okay, I'll start: "I fear what I paint today will never be as good as _____."

forget rules
forget right
remember joy

Kristy Rice

sedum and tomatoes

WHAT I USED:

Kuretake MC2036V Gansai Tambi 36 Color Set +
Dr. Ph Martin's Bombay Black India Ink

HOW I USED:

Color chosen straight from the palette, no mixing.
Used less water for a more opaque and intense
look. Finished the background with black ink,
leaving white in choice areas surrounding artwork.
Finally, added freehand leaves and paint spatter.

joyful tip

Your supply collection should always include a black India
ink. Black watercolor just isn't the same, and nothing can
compare when your page needs that "wow" punch of
contrast in the background.

THE Story BEHIND THE ART

Enjoy the full-size version of this art print on the opposite page, but for now learn
about the soul-changing life behind these words.

*Avoid getting tangled up in the "right" materials or the rules
of painting and just dive in.*

*Worrying about all the how-to's and should-do's of painting
will only prevent you from starting.*

Forget rules, forget right, remember joy!

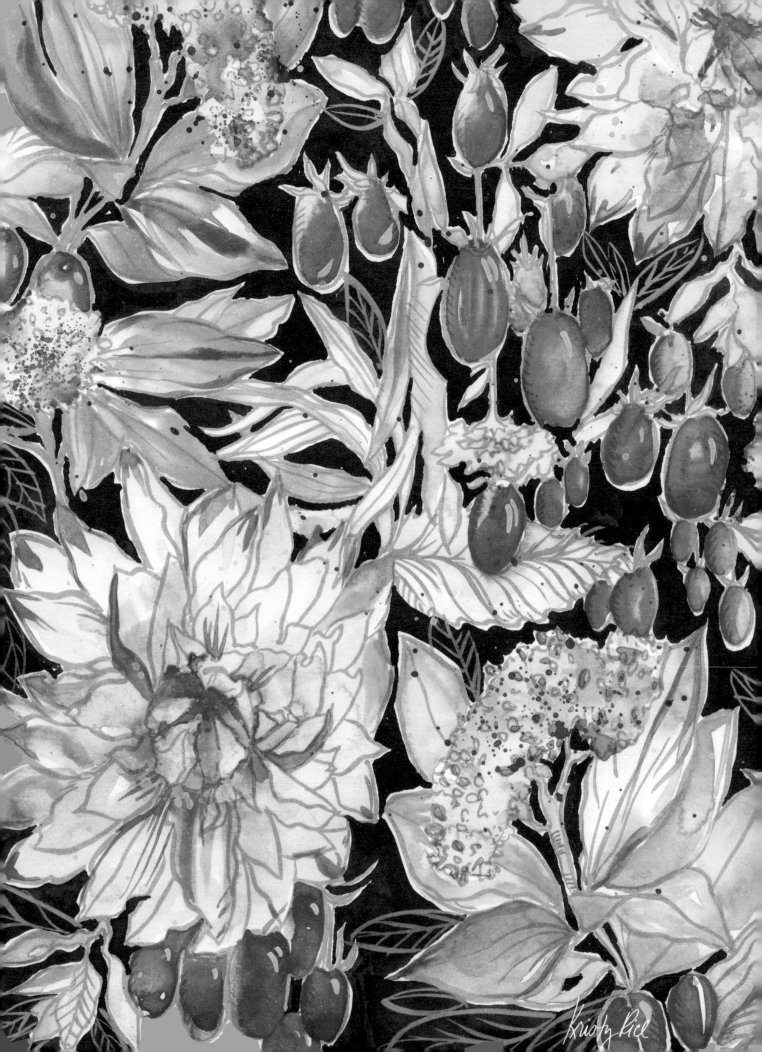

Kristy Rice

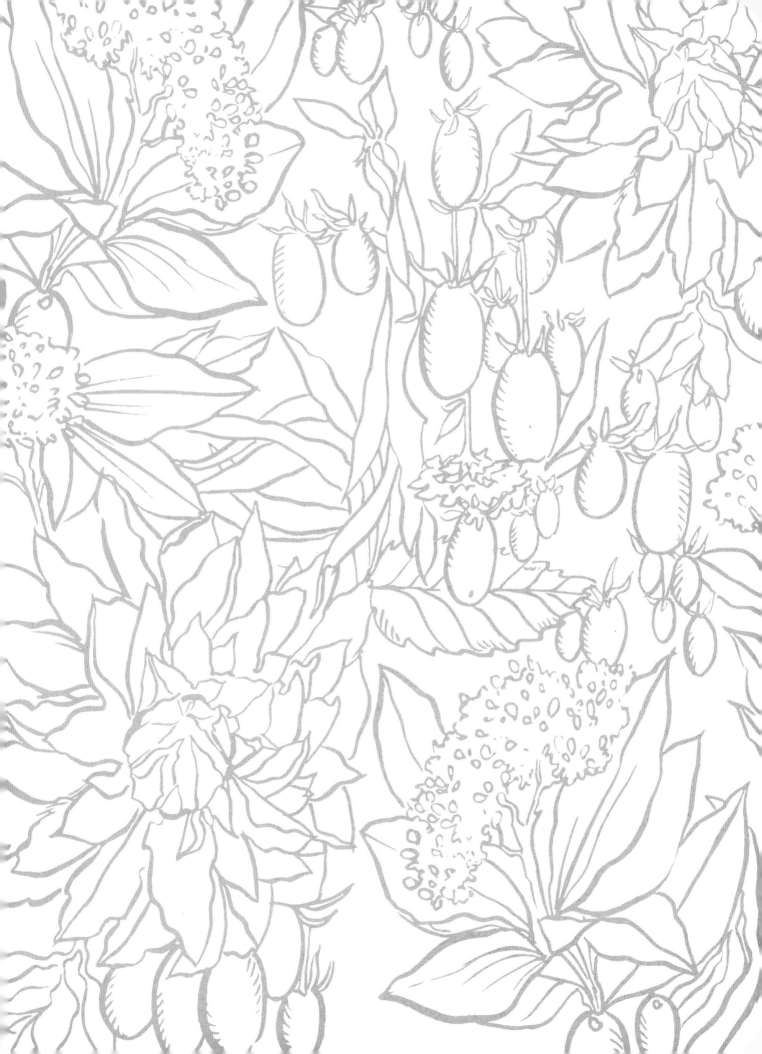

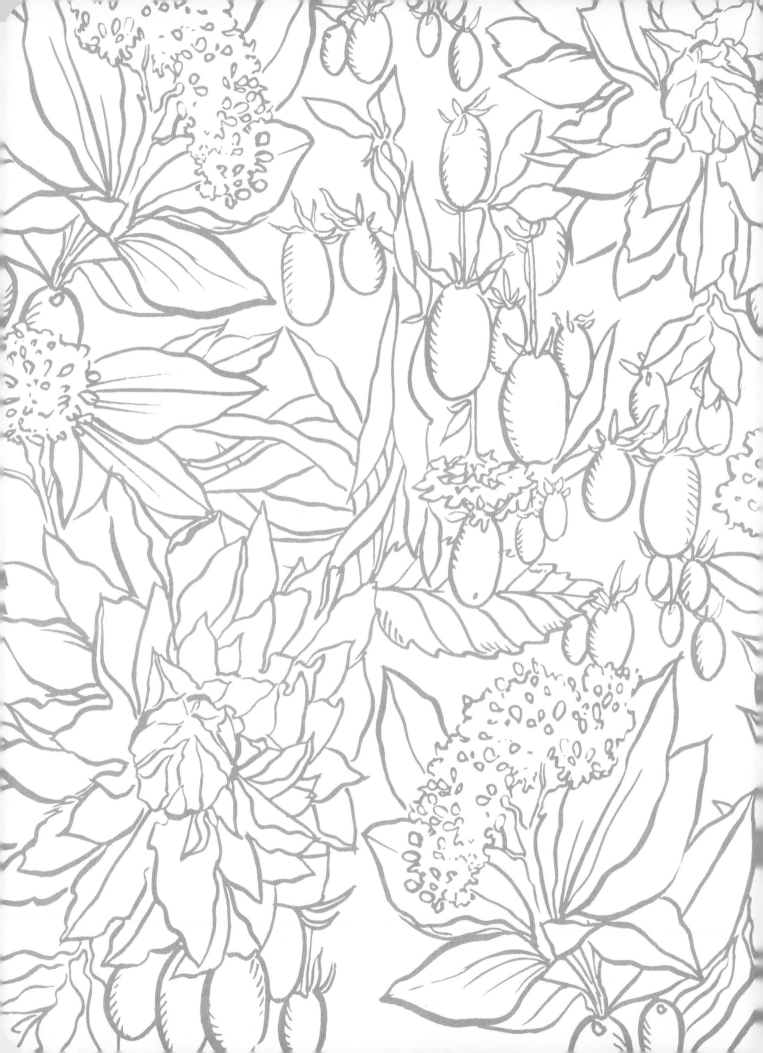

Make the first step the easiest!

We've been told a lie, friends. "The first step is always the hardest . . ." I don't agree. It doesn't need to be. You see, the first step, if small enough, can be the easiest to take. So let's flip this concept around in regard to painting. If the blank page scares you, what tiny step can you first take to combat it? Fill a cup of water and set it next to your paints. Spatter some random color on the page. See, you've begun. Now continue here on this page. Want to paint a flower? Start with one petal, or one stroke. That first tiny step is all you need.

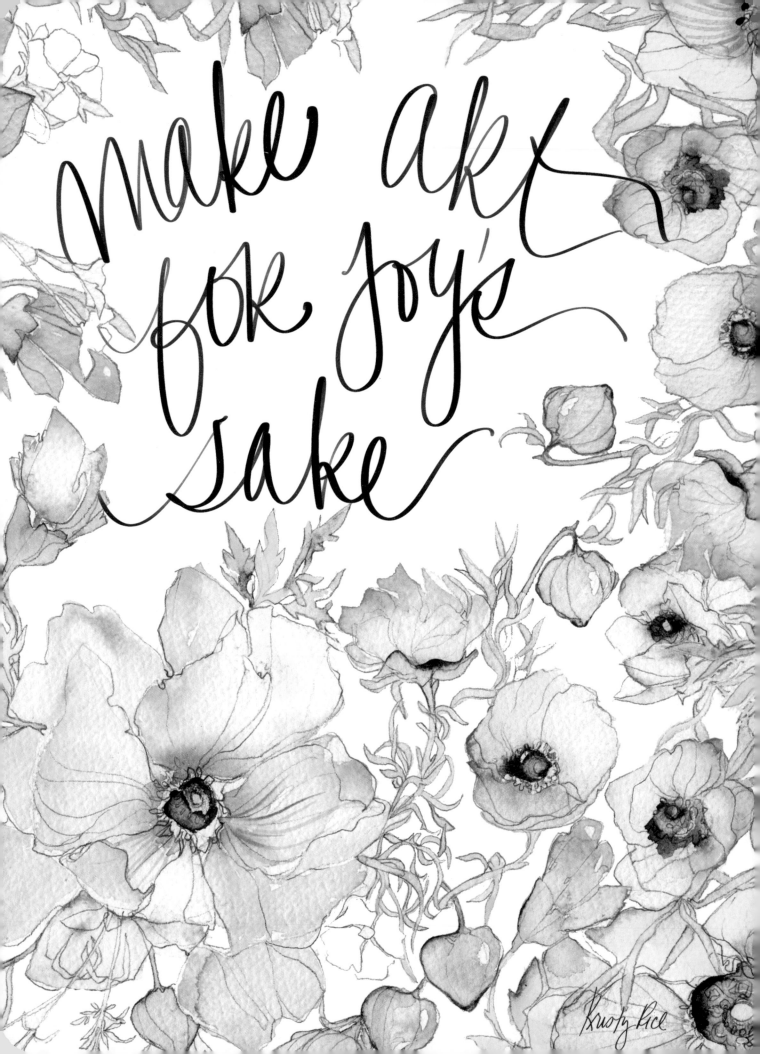

roses and clementines

WHAT I USED:

Mission Gold Watercolors

HOW I USED:

7-color limited palette of bold brushstrokes. Exaggerated contrast between light/dark, muted/bright colors.

joyful tip

Don't worry about mixing colors—choose a few colors and work straight from your palette! Getting overly concerned about mixing the perfect color inhibits your ability to just paint freely without fear.

THE Story BEHIND THE ART

Enjoy the full-size version of this art print on the opposite page, but for now learn about the soul-changing life behind these words.

Happiness is fleeting, it's circumstantial, it comes and goes. But joy, my friend, is impermeable when it comes from a source that can't be shaken.

Making art for the sake of finding joy gives you strength and refuge in all moments if you create with no expectations or agendas. When your art is unconditional, it becomes a joy-guarding armor.

#artforjoysake

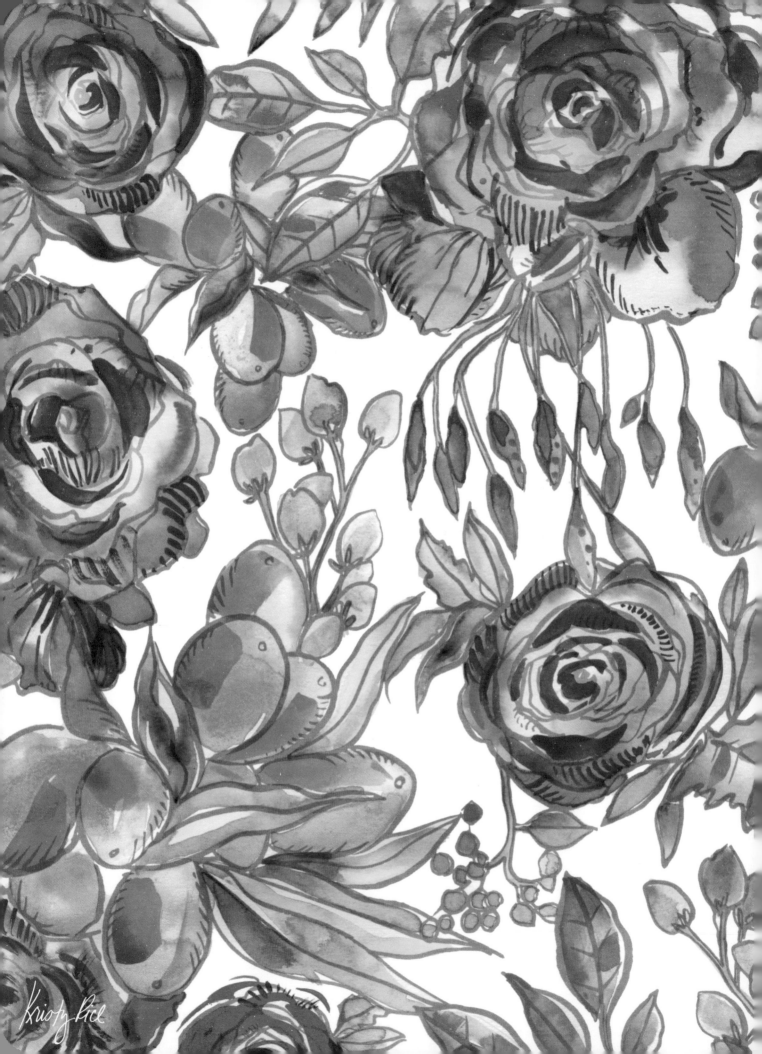

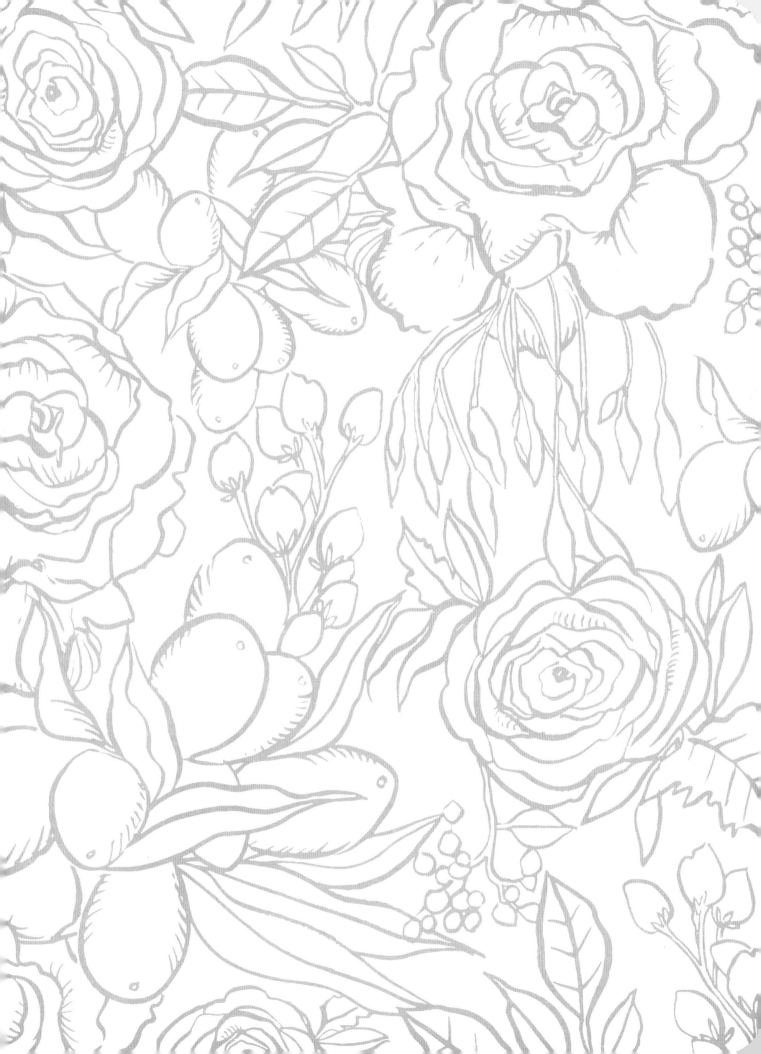

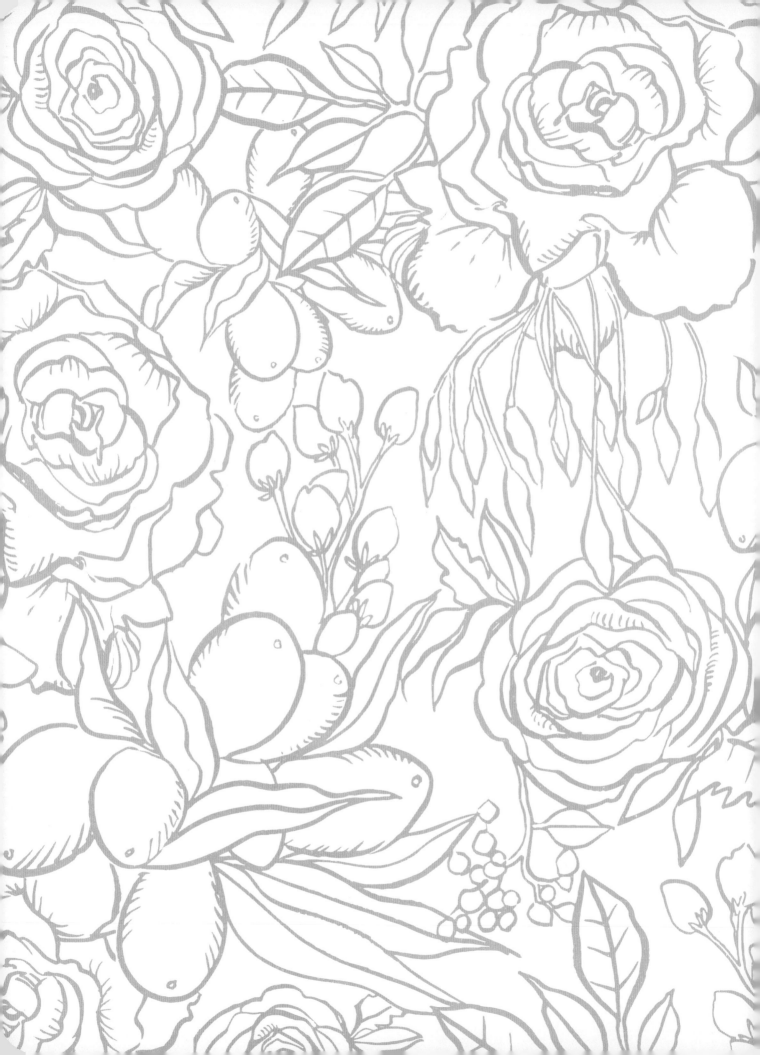

Friends, I cook like I paint . . . a little of this, that, and some prayer that it all looks good. But seriously, these two recipes are my absolute favorite crowd-pleasers and are pretty darn simple to make happen. Typically if I'm hosting more than 4 or 5 friends, I will double or triple these recipes.

I don't know about you, but a yummy snack next to my palette is reason enough to stay put and keep painting! There's something enchanting about setting a beautiful painting table with all the artistic necessities along with a plate of goodies.

½ cup butter (1 stick)
1 cup sugar
2 eggs
2 teaspoons vanilla
1½ cups flour
1 teaspoon baking soda
½ teaspoon salt
1 cup mashed bananas
½ cup sour cream
¾ cup raisins (adjust amount to taste)

Thanks to Jo Jo Gittens for the inspiration on this one.

Preheat oven to 350°F.

Grease 1 loaf pan.

Cream butter and sugar.

Add eggs and vanilla.

Mix dry ingredients in separate bowl and add to wet mixture.

Mix just enough to saturate dry ingredients. Don't overmix.

Add mashed bananas and sour cream.

Fold in raisins.

Spoon the batter into the pan. Bake 50 minutes to 1 hour, or until a toothpick inserted in the center comes out clean. If the top is getting too brown while baking, tent a loosely fitted piece of aluminum foil atop the loaf.

PAINTING PARTY

Collect items used when baking, like measuring spoons and cups, pretty mixing bowls, bottles of vanilla, spices, a vintage linen or two, and of course a bounty of simple fruit. Create a relaxed arrangement in the middle of your painting table. Let the afternoon drift away slowly while you and friends sip tea, snack on banana bread, and sketch the still life in front of you!

best banana bread everrr!

NUTMEG

EXERCISE

Fill the page with as many different types of brushstrokes as possible, using just one brush. Strive for 100 different strokes! Think about the angle you hold the brush at, the pressure you apply, and using the brush tip versus the side.

joyful tip

A dagger-style brush will give you amazing results here, even as a beginner!

pomegranates and figs

WHAT I USED:

Holbein Watercolors

HOW I USED:

Full palette of colors applied over several layers and dried between each application. Loose detail added with more-intense versions of base color.

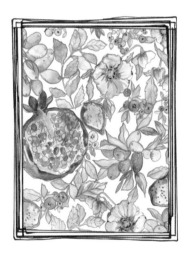

joyful tip

More water + pigment = great for bold washes of color.
Less water + pigment = great for final details.

Live loved and make good art!

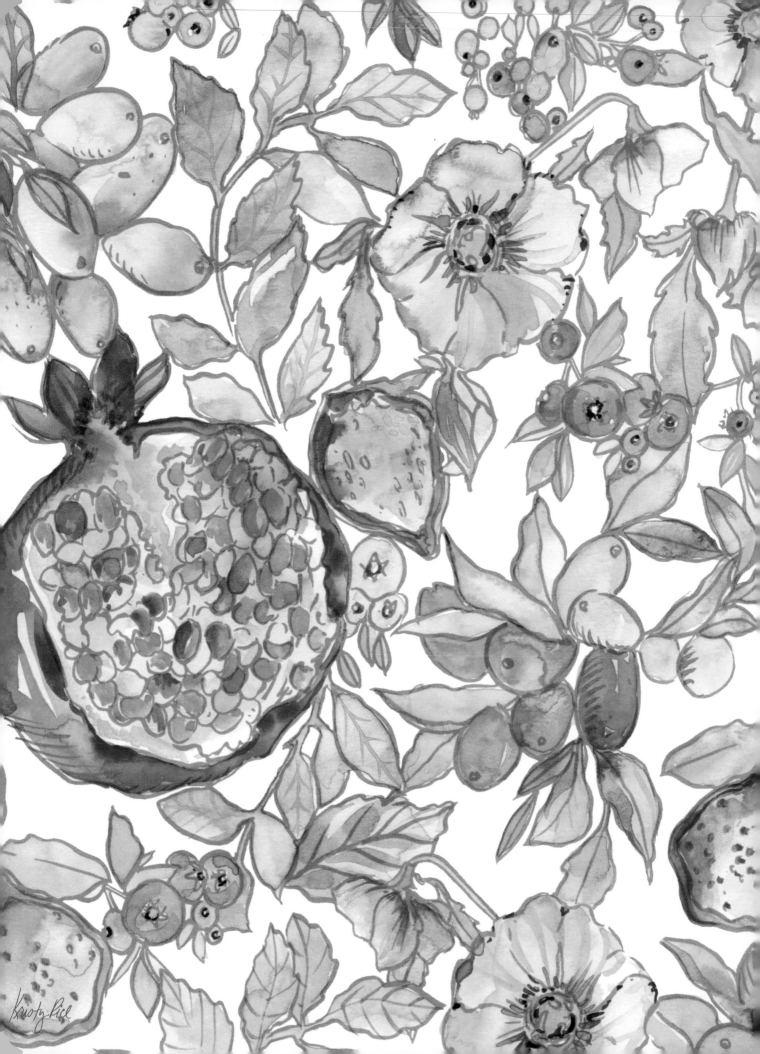

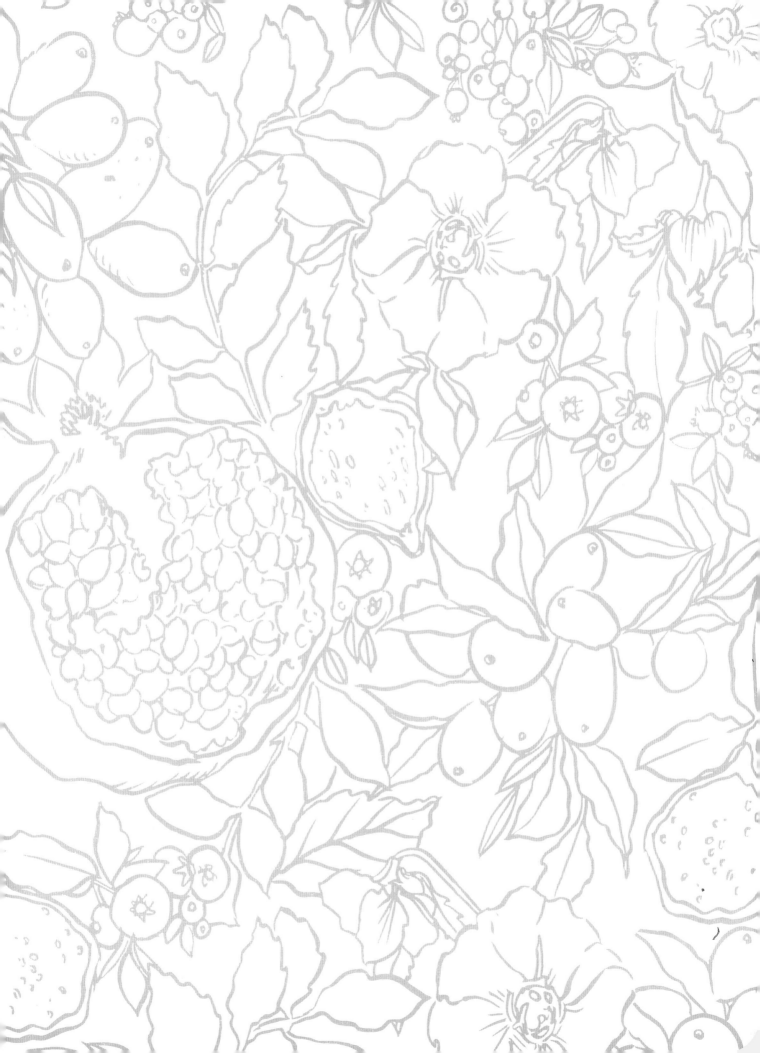

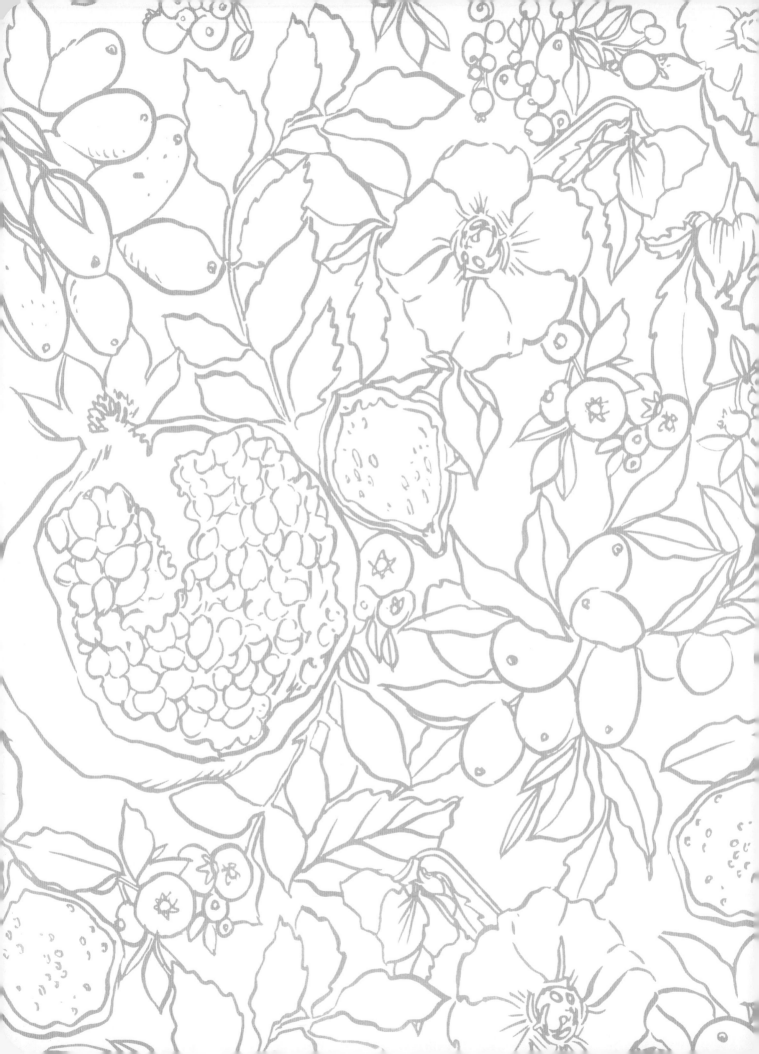

 Write down, sketch, or paint the 10 things you love about making art. Jump in, use the materials you have, and make these pages about expression. Don't think too much, just let your heart and fingers take the lead! Tear bits from old books, collage, go abstract—let your emotions translate into color and shape. Okay, I'll go first. I *love* that moment when Daniel Smith's Moonglow starts to dry on the page and three different colors emerge out of one!

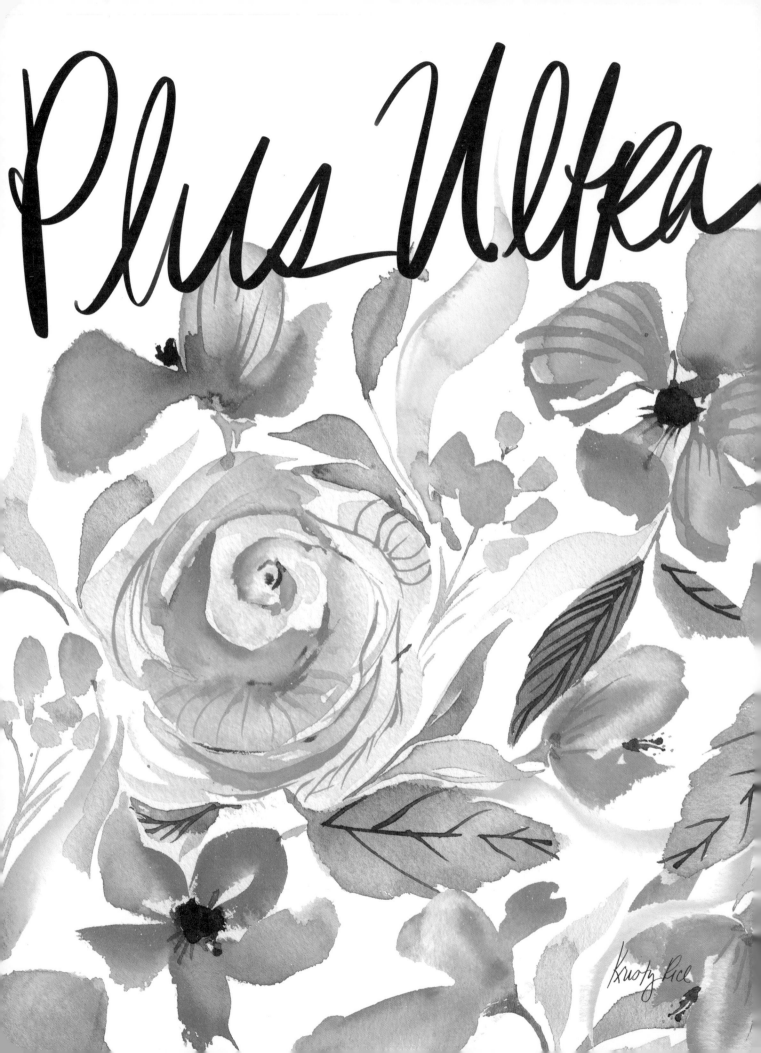

big dahlias

WHAT I USED:

Zig Clean Color Real Watercolor
Brush Pens

HOW I USED:

Layer upon layer of yellows, oranges,
and pinks added light to dark. Tip
and broad side of brush used. Kept a
waterbrush at hand to blend and add
more moisture to the page.

joyful tip

Water-based markers don't give that
expressive watercolor look, so don't get
discouraged as you first begin. Soon
you'll see that the layering of the colors
between broad, bold marks and small,
fine details is where the fun is at!

THE Story BEHIND THE ART

Enjoy the full-size version of this art print on the opposite page, but for now learn about
the soul-changing life behind these words.

*Years ago, the hubs and I toured Fonthill, Henry Chapman Mercer's ec-
centric tile-laden home that was literally built from the inside out. Tiles
featuring the words "Plus Ultra" were set in a massive fireplace that
caught our eye as we toured. As I repeated the words "More
Beyond" in whispers to myself, the literal translation was
like a loud clanging in my soul.*

*There is always more beyond where we are now. The
more beyond that you commit to discover is where your
art-making mojo lies. Go find it.*

Meet yourself where you're at.

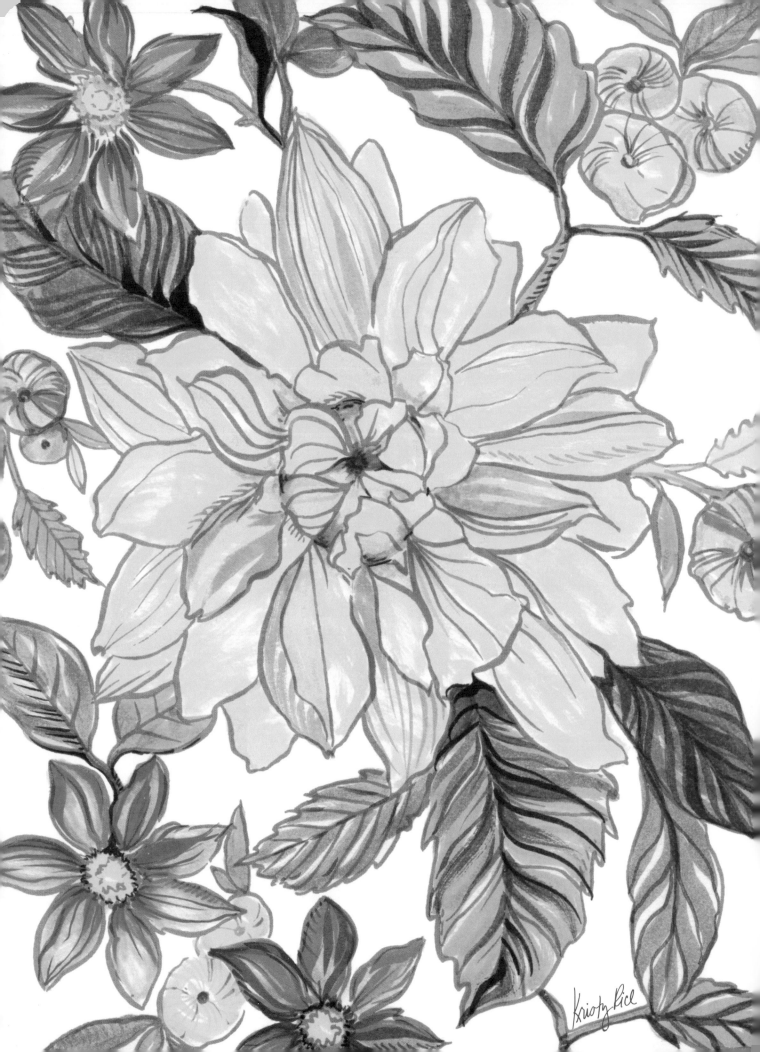

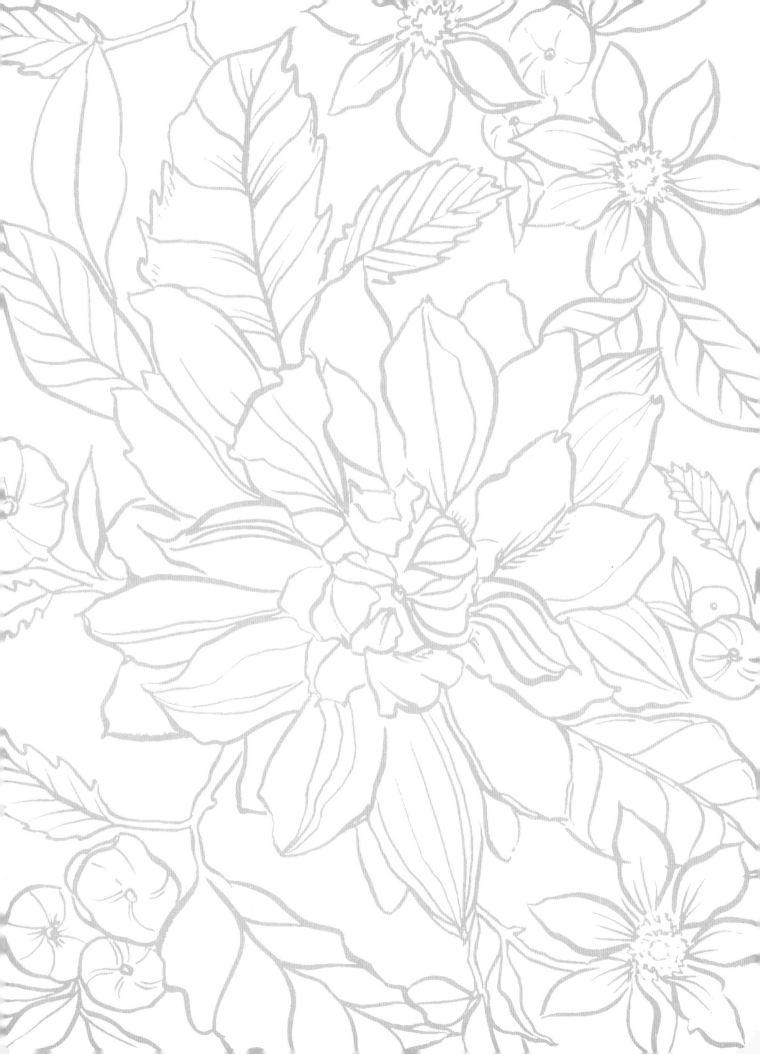

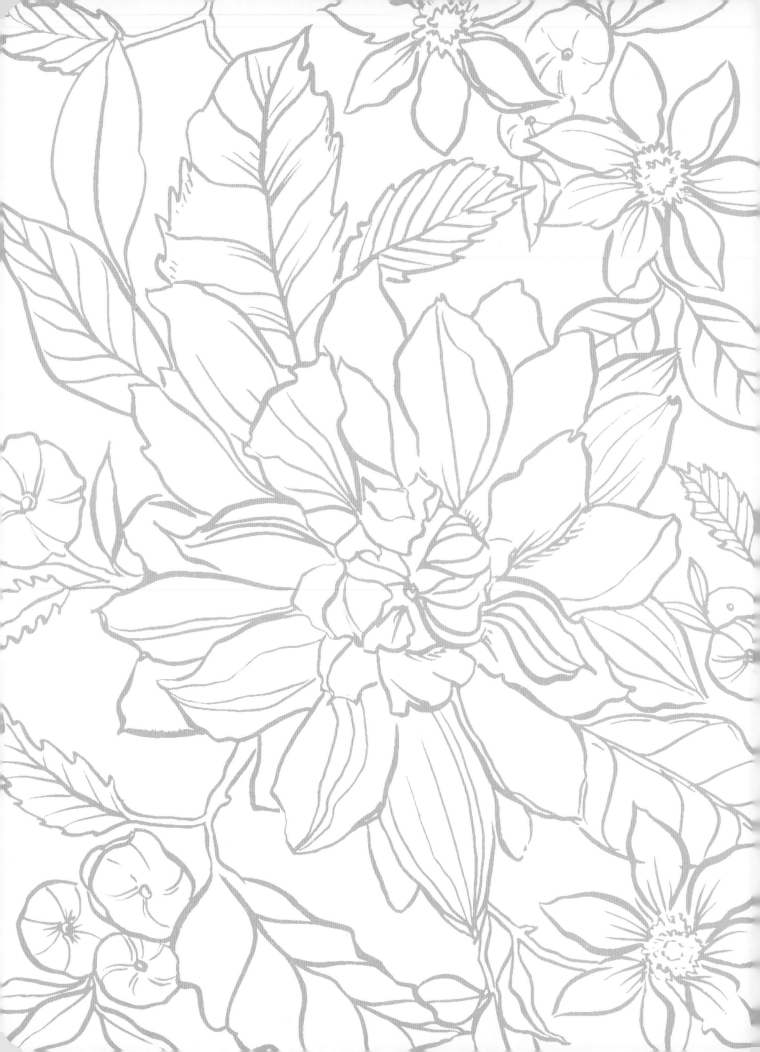

What Is Your NEXT ?

The word "next" usually implies something better, more evolved, or at least the place where you wish to be instead of here. But I like to think of The Next as a place where you are next *meant* to be. The Next isn't a judgement on where you are now. It is a calling, a movement toward a higher purpose built upon every experience you've already had. So where are you to be next? Paint your next. Let these pages be filled with wild color, pencil doodles, brainstorms, and wholeheartedly scribbled words let loose from where all your fearful instincts live.

QUICK WAYS TO GET ARTISTICALLY MOTIVATED

Not wanting to lift a finger except to hit play on the next TV binge? I hear ya, and trust me, every creative soul has their moments. When your soul wants to create but your mind is in a different state, give these spirit-lifting tasks a try! Some of these may feel overly simple, but often all we need is a slight nudge in the right direction.

1 Diffuse a blend of uplifting essential oils like lemon, sweet orange, and grape-fruit. Take 7 deep breaths nearby (in through the nose, out through the mouth). I feel a loose and sketchy watercolor pattern of fruit coming on!

2 Take a quick walk outside, even just to your front porch or backyard. Promise yourself 5 minutes to look around and just be in that moment. Time yourself if needed!

3 Get up and prepare the place where you'd like to create. Just the act of getting your space ready will be motivating.

4 Make a cup of tea. One of my favorites is a peach matcha. There is something sacred about boiling water, drizzling a bit of honey, and waiting for the crisp, fruity tea to brew. As your senses awaken from the aroma, your creative juices will undoubtedly begin to flow. While waiting for the tea to brew, why not try a quick sketch of the tea tin?

5 Grab an old painting you never had a chance to finish. There's nothing saying you always need to start fresh with a clean page. There is some-thing invigorating about rescuing a sad, old piece that you never thought would come back to life!

plums and peonies

WHAT I USED:

Daniel Smith Watercolors and graphite

HOW I USED:

Here a monochromatic palette of purples, blues, and greens was used. Once dry, a sketchy finish of pencil markings was added.

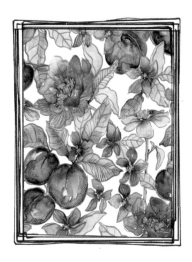

joyful tip

You can add graphite to wet paper if you enjoy picking up color and moving along the page with your pencil. Stay away from mechanical pencils here, though—the sharp tip of the mechanical pencil can damage the paper when wet. Stick to the traditional wood barrel variety.

Put brush to paper and just make something!

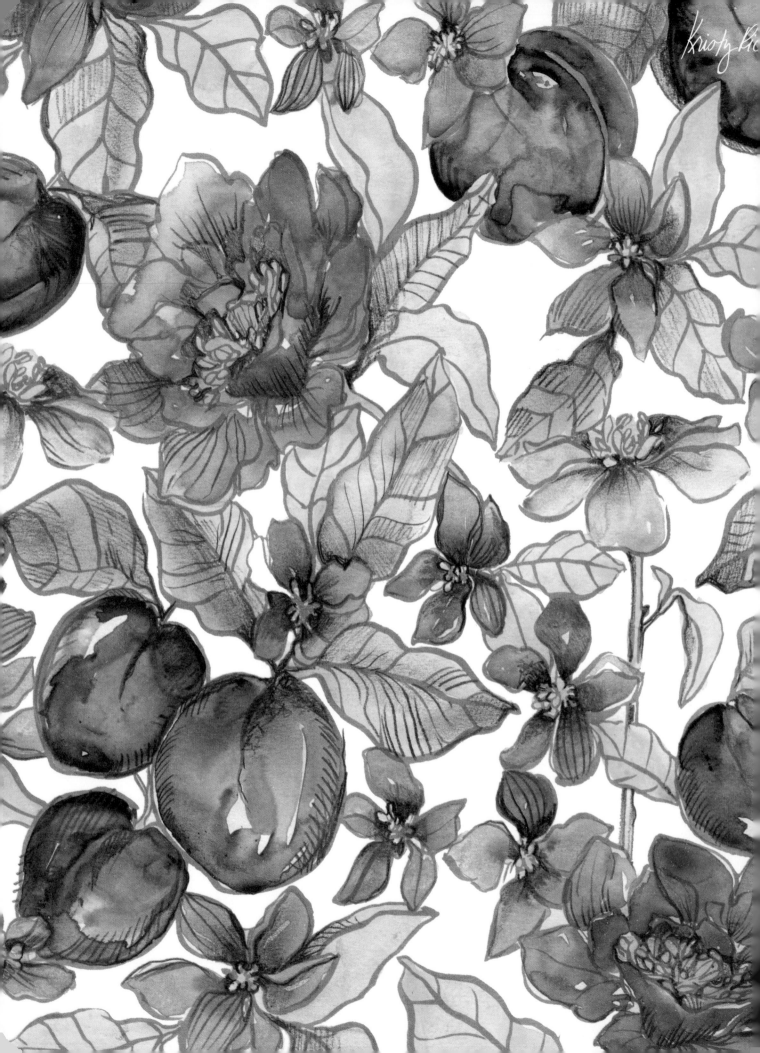

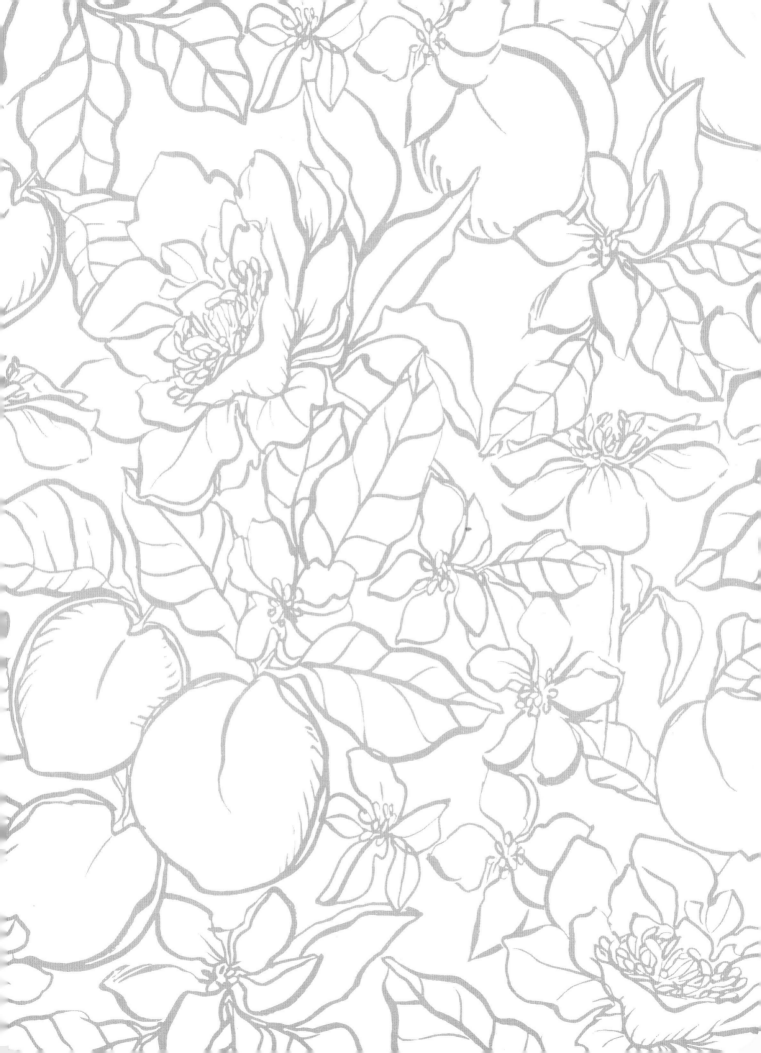

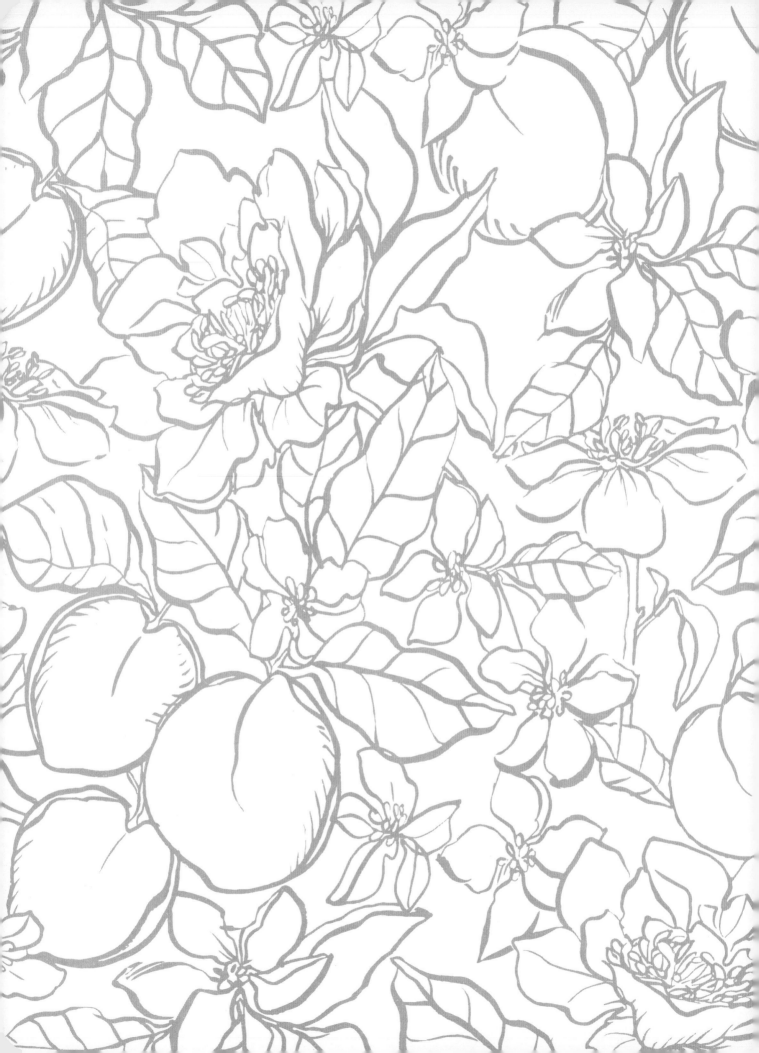

EXERCISE

Fill the page with watercolor circles created from intense color and lots of water. First trace the base of a cup or jar so you don't have to worry about making perfect circles freehand! If you're *still* nervous, paint the circles first with clean water, then drop in color!

joyful tip

More-saturated inks make for a super-satisfying experience here. Beginner watercolor sets won't give you that vibrant burst of color. Even just 2 or 3 bottles of your favorite colors will make all the difference.

best bruschetta everrrr!

This bruschetta has two parts . . . wait for it . . . the tomatoes and the cheese! But I guarantee that if you make this for a painting night with friends the inspiration will abound!

The Bread

1 long, skinny loaf of crusty bread
¼ cup extra virgin olive oil
Coarse salt

The Tomatoes

2 cups chopped tomatoes
1 tablespoon chopped garlic (from a jar is fine)
Few pinches of salt to taste
Few turns of ground pepper to taste
Splash of lemon juice
⅓ cup extra virgin olive oil
¼ cup balsamic vinegar
Splash of apple cider vinegar to taste

The Cheese

1 8-ounce package cream cheese,
 at room temperature
1½ cups crumbled feta
Few pinches of salt to taste
Few splashes of lemon juice
¼ cup extra virgin olive oil

Slice bread into ¼-inch slices and arrange on baking sheet in single layer.

Using a pastry brush, paint on olive oil.

Sprinkle with coarse salt.

Bake 7 to 10 minutes, depending on crispness preference.

Mix "The Tomato" ingredients together. Yup, all at once, no fuss, just get it all in a bowl.

With a hand mixer, blend on high all "The Cheese" ingredients. Yup, all at once. Blend until reasonably smooth. Taste and add additional flavors as needed.

Spread generous amounts of "The Cheese" on the baked bread slices and top with a heaping spoonful of "The Tomatoes." You can thank me later.

PAINTING PARTY TIP

So first you cook, then . . . you paint!! Pick up extra tomatoes at the market, the more colorful and interesting the better. Mound them at the middle of the table and sit with friends around the bounty with painting supplies at the ready. Ask everyone to bring their favorite brushes, paints, and paper with the intent to share with all. This is a great way to explore different materials without making a huge investment!

dogwood and chevron

WHAT I USED:

Crayola Washable Watercolor

HOW I USED:

Bright palette of colors intensified with 3 layers of colors dried in between each application. Richer color accents added in wet areas to encourage soft flooding together of pigments.

joyful tip

There is nothing more satisfying than painting with super-affordable materials and getting a beautiful result. Affordable watercolors meant for kids are great when just starting out, since beginners tend to worry about wasting expensive art supplies. No worries here! Keep these finished pieces out of direct sunlight, though, as they can fade.

There's no fear in art.

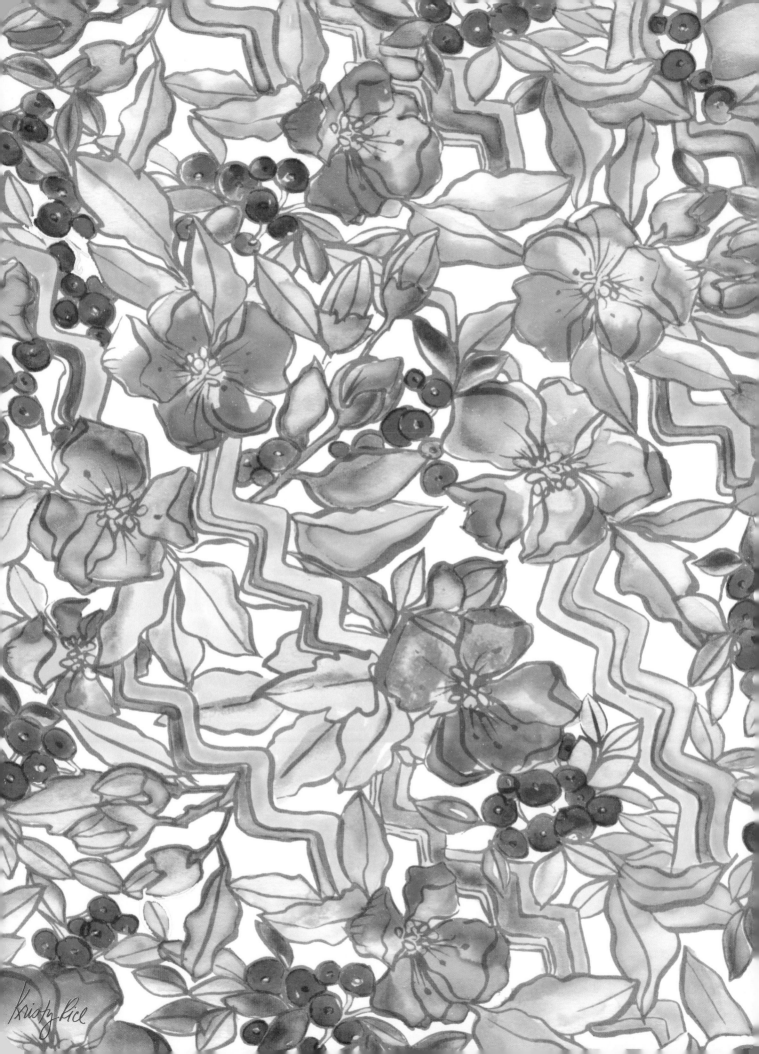

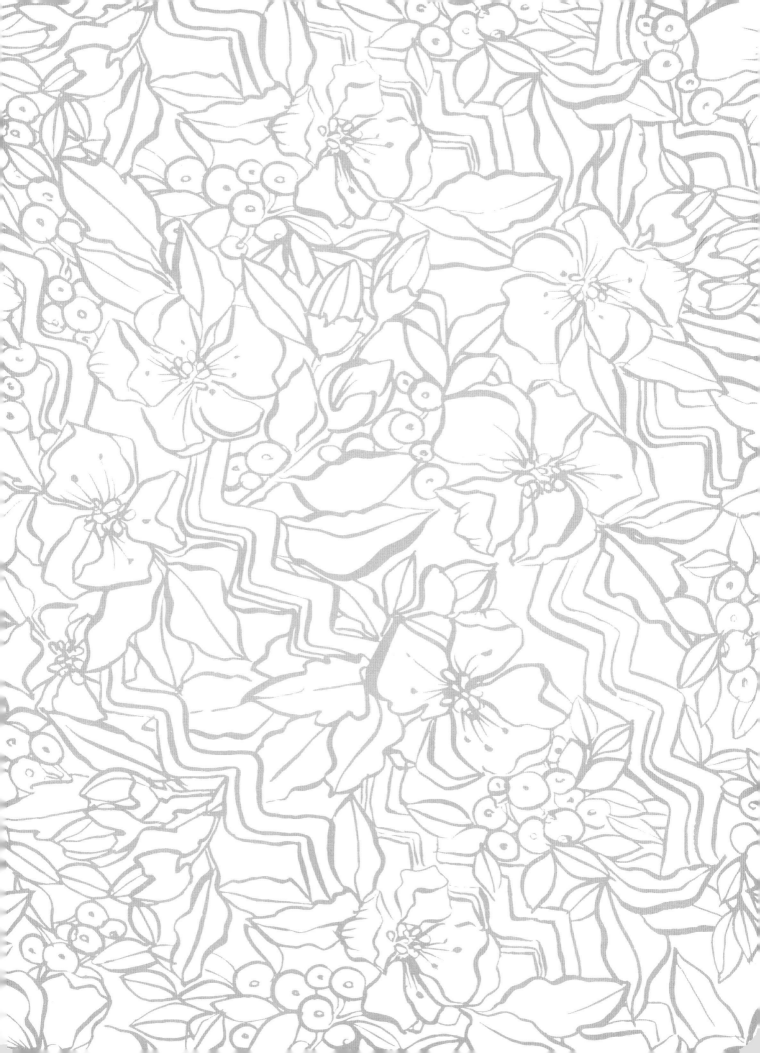

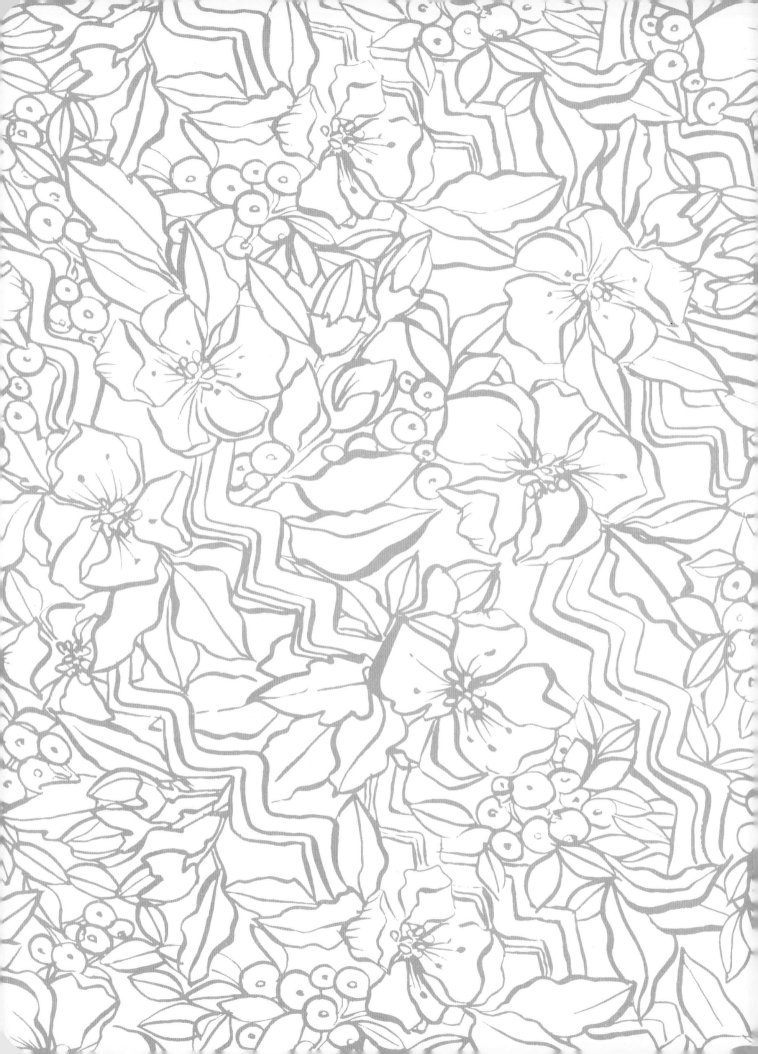

Paint swatches of some color combinations you love.

Think in color palettes of 3 to 5 shades and fill these pages with as many palettes as can fit. Now you'll have a storehouse of your favorites ready to inspire any future project! You can create color palettes in a variety of ways: little hearts of color, tiny circles, a few similar brushstrokes next to one another. Need inspiration? Flip through a magazine and see the colors being used in ads for home goods, makeup, and clothing!

These colors make me feel / remind me of / will work well when:

[happy / beach / using blues]

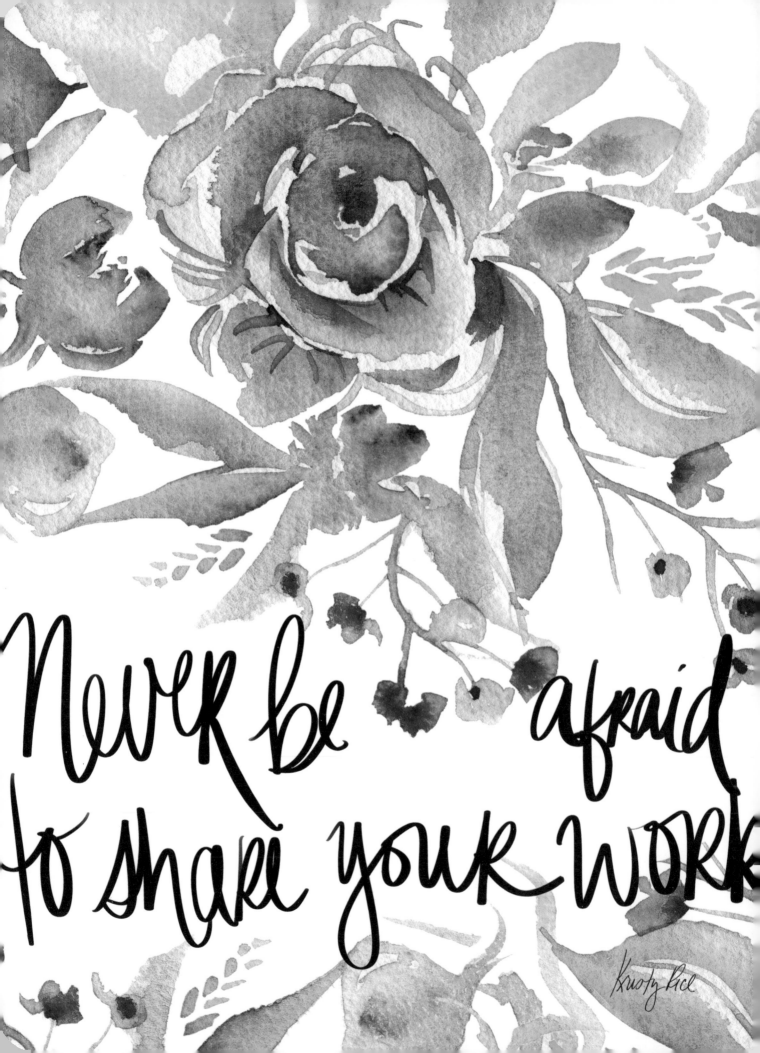

mexico

WHAT I USED:

Artist's Loft Fundamentals Watercolor Pan Set, 36 colors

HOW I USED:

Muted shades of green, red, teal, orange, and lavender with detail added using a smaller brush over dried layers of watercolor.

joyful tip

Don't stress over choosing a color palette. In fact, when you're just beginning don't worry about the exact colors you're using—meaning don't stress over having Alizarin Crimson or Cerulean Blue in your collection. Just pick up a nice set with a variety of pretty colors.

THE Story BEHIND THE ART

Enjoy the full-size version of this art print on the opposite page, but for now learn about the soul-changing life behind these words.

Share, share, share!

Join a YouTube channel community, post to a favorite hashtag, start a Facebook group! The point is getting to know other artists. You'll quickly learn that we're all experiencing similar struggles regardless of our skill level, and this realization, my friends, is infinitely comforting!

A good choice that gets you started is better than the perfect choice.

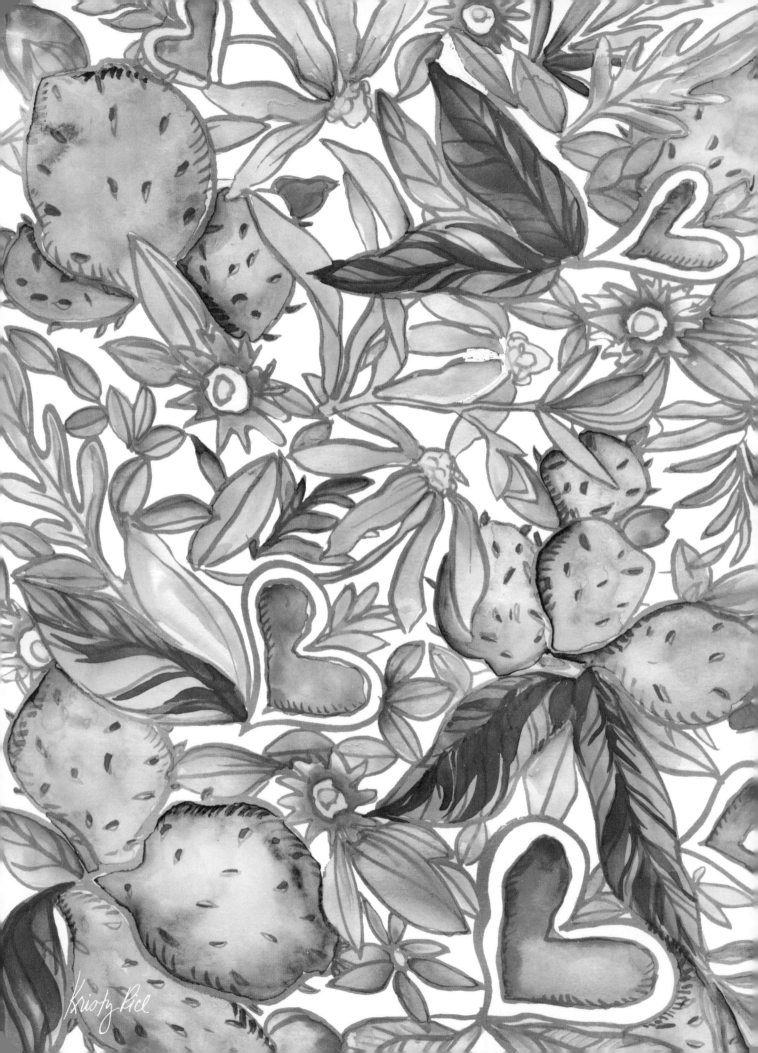

Document the colors of a leaf. Go outside and grab a leaf. Using what supplies you have, try to create swatches of all colors seen in the leaf. Push yourself to discover, mix, and document at least 10 colors. Feeling adventurous? Document at least 20 greens—let your eyes relax . . . is there sun shining on the leaf? Is there a red flower next to the leaf? Well then, golden yellows and even oranges had better make your swatch list!

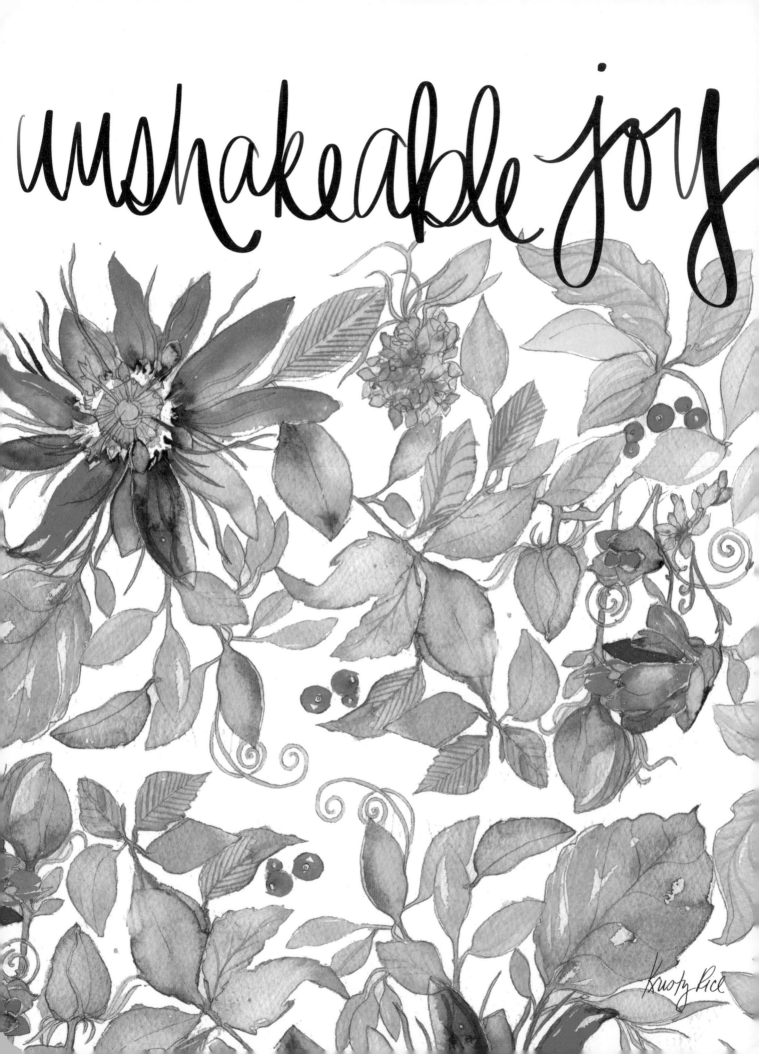

blooming oRanges

WHAT I USED:

Brea Reese Watercolor Inks

HOW I USED:

Color directly from the bottle added to wet page to create strong yet unpredictable bursts of pigment.

joyful tip

You will get paint on your hands. Be okay with paint on your hands. Own the mess; you can wash your hands later. It's difficult to make something fabulous if you're always worried about making a mess. Just keep plenty of paper towels handy.

THE Story BEHIND THE ART

Enjoy the full-size version of this art print on the opposite page, but for now learn about the soul-changing life behind these words.

Find your unshakeable joy.

Mine is in God and my art. Find yours, because when you do, it is a place like no other.

There is a simple magic in the mess!

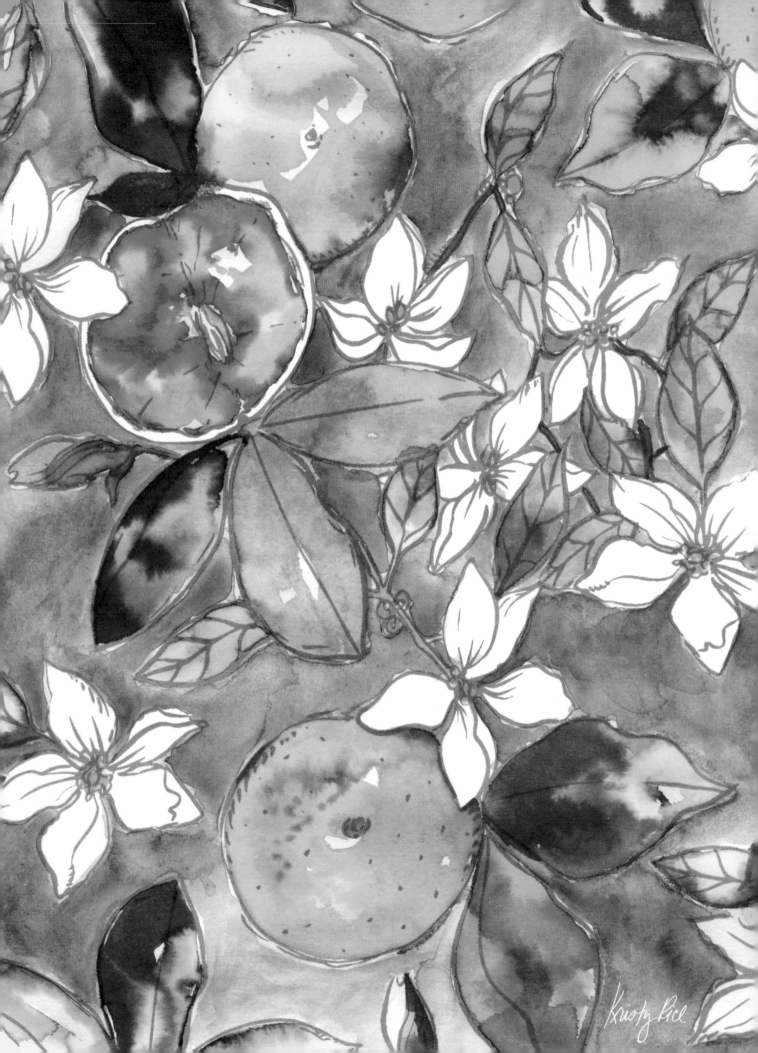

Kristy Rice

***Watercolor sketch the items on your next gro-
cery or shopping list.*** Trust me, bananas and cookies can be super
fun to sketch when inspiration is otherwise lacking. Looking to the everyday never
fails to invigorate the creative senses.

EXERCISE

Fill the page with stripes of all sizes. The broad side of the brush makes thick stripes of various widths, depending on pressure. Using the brush's tip will produce thin, delicate stripes.

joyful tip

Consider making stripes with sponges, a piece of paper towel rolled around your finger, or even slices of raw potato (dipped into paint like a rubber stamp). Don't be afraid to put the brush down for this one.

peony garden

WHAT I USED:

Kremer Pigmente Fluorescent Watercolor Set

HOW I USED:

Single layer of color added to dry page, leaving most leaves white. Once first layer was dry, fine contour lines were added to select leaves and petals.

joyful tip

An exhilarating painting experience doesn't need to be long and laborious. One layer of beautiful color on the page can often be all you need to feel good about a creation. Challenge yourself to just wet the whole page and drop color in as the page dries. Let the water naturally move the color around. Let dry, and then begin adding more detail.

Five minutes today. It's all you need.

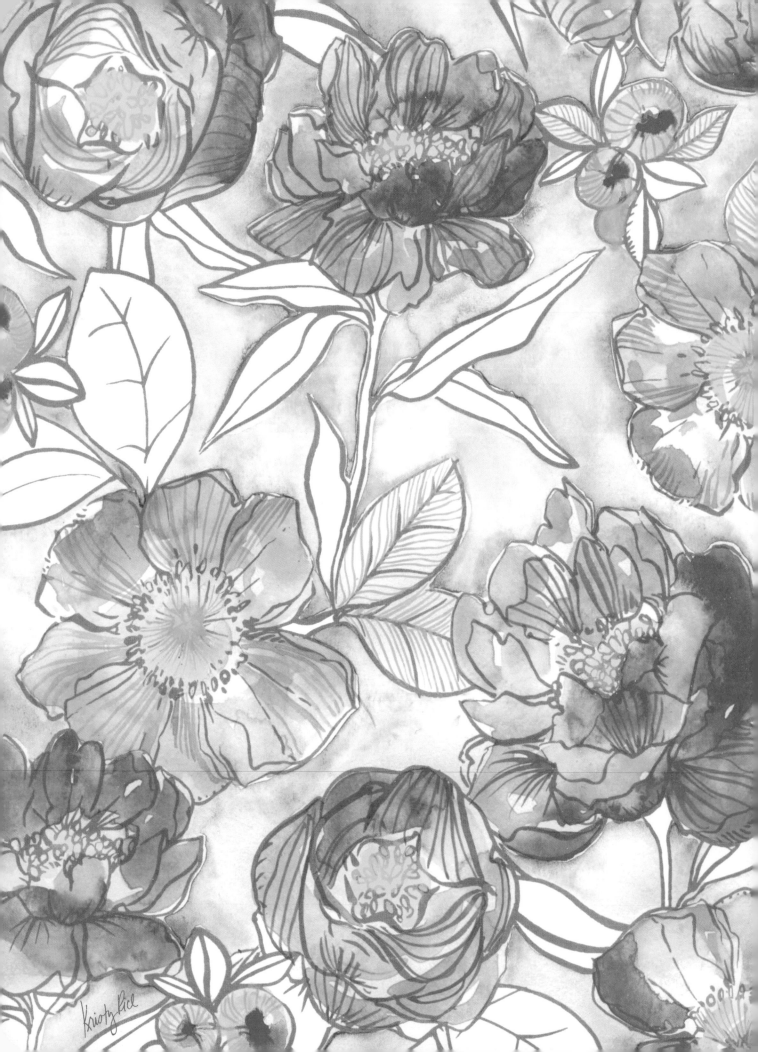

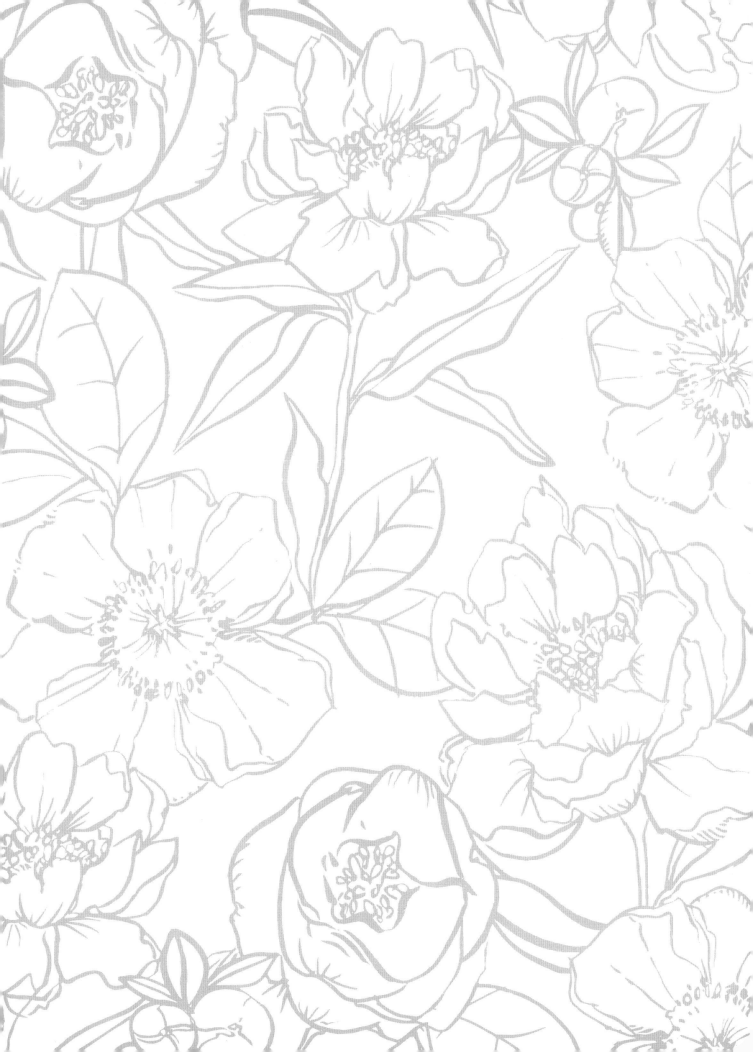

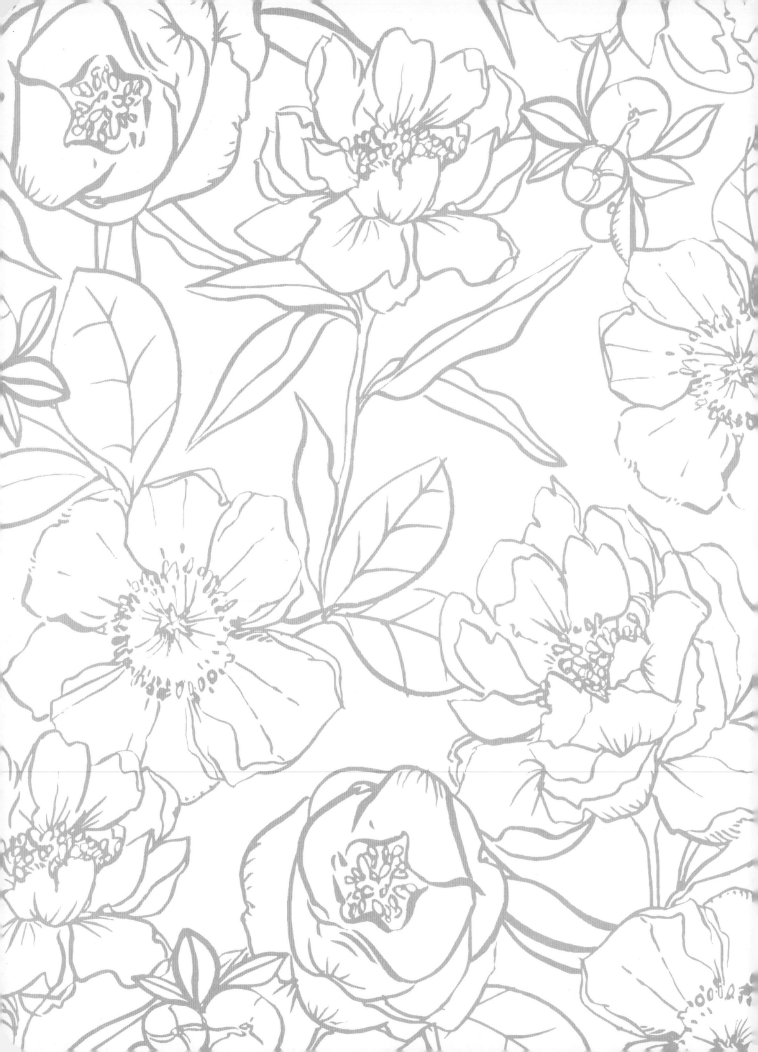